Joanna Sheen
Paper Lace
Greetings Cards

SEARCH PRESS

First published in Great Britain 2008

Search Press Limited
Wellwood, North Farm Road,
Tunbridge Wells, Kent TN2 3DR

Text copyright © Joanna Sheen, 2008

Photographs by Roddy Paine Photographic Studio

Photographs and design copyright © Search Press Ltd. 2008

ISBN: 978-1-84448-407-2

The Publishers and author can accept no responsibility for any
consequences arising from the information, advice or instructions
given in this publication.

Readers are permitted to reproduce any of the items in this book
for their personal use, or for the purposes of selling for charity, free
of charge and without the prior permission of the Publishers. Any
use of the items for commercial purposes is not permitted without
the prior permission of the Publishers.

Suppliers

All of the materials and equipment used in this book can be
obtained from the author's own website: www.joannasheen.com,
which distributes worldwide.

Alternatively visit the Search Press website for details of suppliers:
www.searchpress.com

Publishers' note

All the step-by-step photographs in this book feature the
author, Joanna Sheen, demonstrating how to make paper
lace greetings cards. No models have been used.

Printed in Malaysia

Dedication

To all the people who work so hard with me for Joanna
Sheen Limited – you are all very, very much appreciated.

Acknowledgements

As always, thanks to Search Press – particularly
Roddy Paine for the photographs and Katie Sparkes
for the editing.

A big thank you to my family too for being
understanding when yet again I disappear into my
craft room to make cards rather than cook dinners!

And thank you to all the crafters who email or write
to me and make it such fun to be involved in the
crafting world.

*The front cover shows the Victorian Bride card featured on
pages 24–27.*

Contents

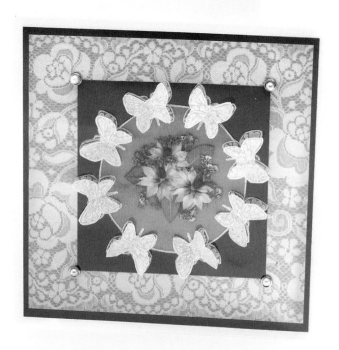

Introduction

Lace is a fabulous ingredient to use in many crafts, and cardmaking is definitely one of them. Adding some lace will soften a design and heighten its femininity. Lace, or lace effects, come in many varieties, and in this book you will find lace made from paper, lace that has been laser cut, lace you make yourself by stamping and embossing on parchment, lace paper doilies and various ideas for incorporating lace into your designs in different ways.

Fabric lace can be very effective too, but in this book I have tried to confine the designs to those using only papercraft and cardmaking techniques. I would recommend trying a range of methods, such as stamping and embossing or using ready-made paper lace, and see how lace can add something really special to your cards!

Joanna Sheen

Opposite
A selection of greetings cards that you can make using the techniques shown in this book.

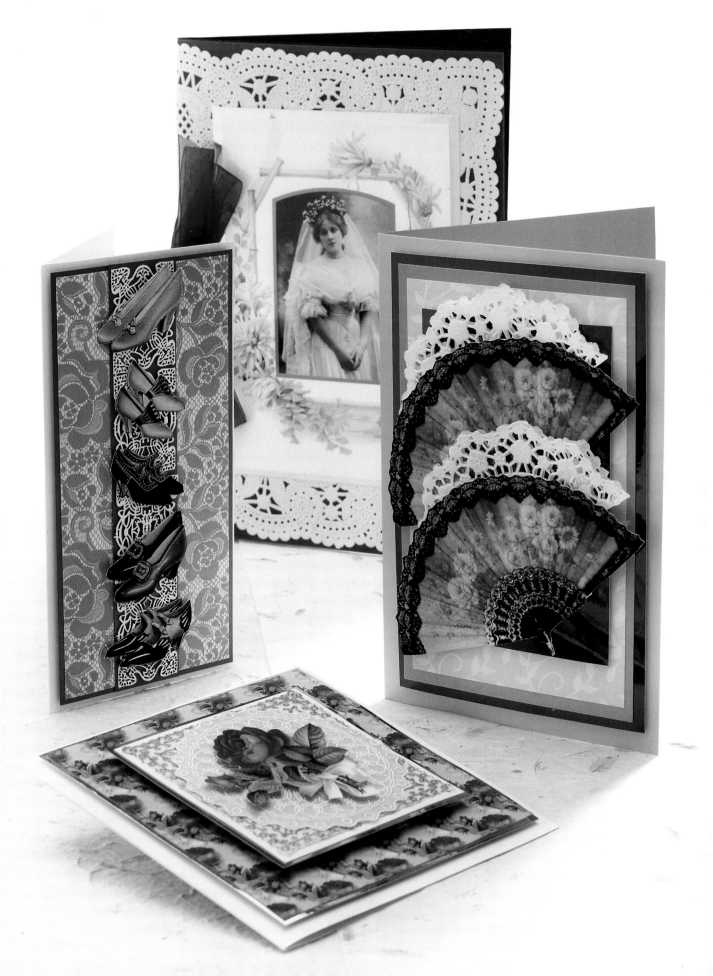

Materials and equipment

Cardmaking is no different from any other hobby or creative endeavour – if you use only the lowest quality ingredients you will need a great deal of skill to make them into something special. So it is with greetings cards – if you use good quality materials and equipment then even the simplest cards will have a professional finish. Having said that, most papercraft supplies are relatively cheap, and with a little imagination anyone can design beautiful, handmade cards for all occasions.

Basic equipment

Once you have collected the basic equipment needed for making greetings cards, you will only have to invest in more if you choose to venture into specialist or more advanced techniques.

A large, preferably A3-sized craft mat is an essential, both to protect surfaces and to act as an extra spongy layer when stamping. I also use a small glass mat from a kitchen shop for heat embossing – if you use a standard craft mat the heat will damage it. A good, accurate guillotine is my main standby and would definitely be my desert island crafting essential. Tweezers, a craft knife, good scissors, decoupage snips, a bone folder and a clear ruler are also very useful.

You will gradually collect various glues and adhesive tapes, and find your personal preference. I like double-sided tape and foam tape, but I also use a lot of silicone glue for both flat and three-dimensional work. I also keep a supply of cocktail sticks which come in very handy for applying silicone glue, positioning small embellishments and many other tasks!

Finally, extra tools you will need for the projects in this book include a heat gun for embossing (any variety will do), clean brushes, a pencil, a Japanese screw punch (for making holes) and some decorative corner punches.

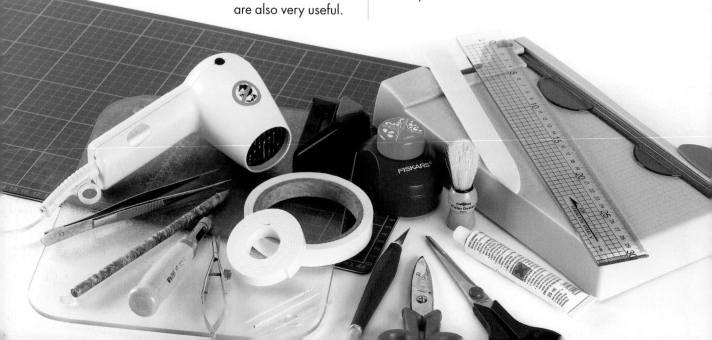

Papers and card

Collecting papers and card can become quite a fixation. If I see a really beautiful design I feel I have to buy it, and if it is pretty enough I may just add it to my collection and not even use it! You will need a good supply of reasonably heavyweight cardstock – don't economise and use flimsy card, as the end result will always look amateurish.

If you are using a crafting CD for your projects, then you can print out the designs on a variety of papers or card, but my personal choice would be inexpensive photographic paper (gloss or satin) with good-quality settings to make the most of your images. There are numerous different media available for printing on from your home computer, including canvas, acetate, vellum and foil, so try experimenting, developing new ideas that will excite and inspire you.

There is a wide variety of papercraft CDs on the market. These can bring a whole new dimension to your cardmaking.

A selection of pre-printed and plain cardstock and papers.

Paper lace products

There are quite a few products on the market that reproduce lace in paper form, and they can all be used in cardmaking to create different effects. Paper lace doilies are very traditional and have appeared on cards since Victorian times. It is always worth looking out for small-scale designs, such as the doilies that go under glasses and cups, as they work so well on greetings cards.

Also available are pre-printed lace designs on paper and card, adhesive paper ribbon, and laser-cut and die-cut paper lace designs, as well as motifs and embellishments such as self-adhesive gemstones, jewellery, buttons, ribbons and pearls that can be used to enhance your paper lace cards.

Materials for stamping and embossing

Really beautiful lace can be made by stamping the image on to reasonably heavy parchment and then embossing the design. This entails using a heat gun and some embossing ink and powders. The effect is really beautiful and, depending on your choice of embossing powder, can be sparkly or plain, shimmery or matt.

Right: A selection of paper lace products that can be used for making greetings cards.

Below: The materials needed for stamping and embossing a design.

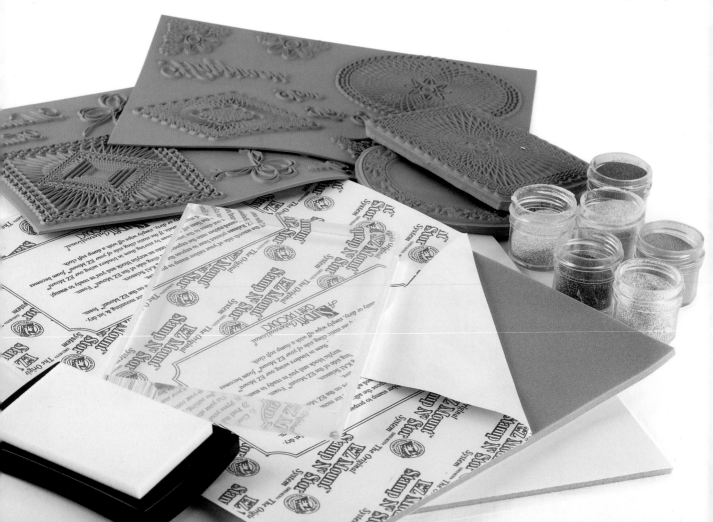

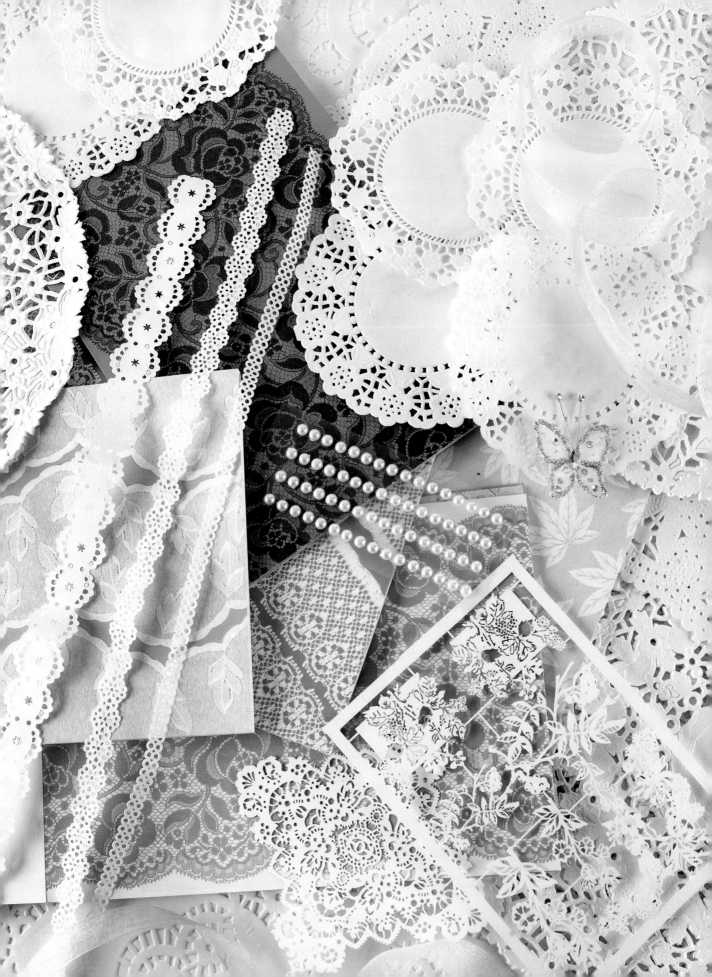

Stamping and embossing techniques

I always use unmounted stamps on a clear acrylic block
as they allow you to see exactly where the design is going
and therefore avoid stamping too far to the left or right,
which has happened to me on many occasions!

Mounting a rubber stamp

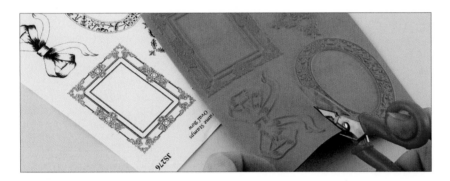

1 Cut around the rubber stamp design, leaving a generous border.

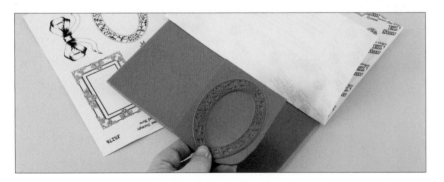

2 Peel the protective backing off the mounting foam exposing the adhesive surface and lay the design on top.

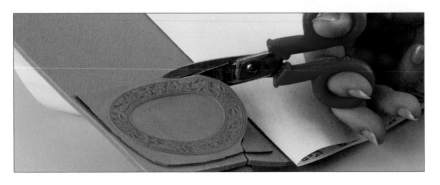

3 Trim neatly around the rubber stamp design.

Stamping and embossing an image

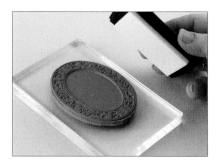

1 Press the rubber stamp on to an acrylic block. Ink the stamp by tapping it gently with an embossing inkpad. Make sure all of the design is covered with the ink, but avoid over-inking otherwise the resulting image will smudge.

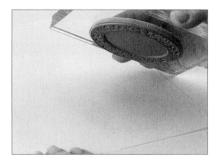

2 Press the inked stamp firmly on to the paper or card surface and lift it off gently to reveal the stamped image.

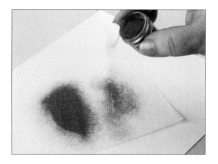

3 Place the stamped surface on to a piece of scrap paper and sprinkle it with embossing powder, ensuring all of the design is completely covered.

4 Tip off the excess powder.

5 Flick the back of the design to dislodge any remaining loose powder.

6 Return the excess embossing powder to the pot.

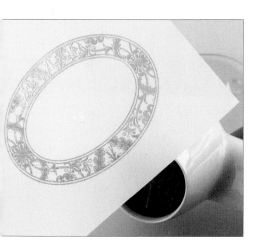

Tip

Heat the back of the design if you are using parchment as it makes the process easier to keep an eye on; heat from above if you are stamping on ordinary card.

7 Heat the design using a heat gun. Hold the heat gun approximately 10cm (4in) from the paper or card. Avoid over-heating – remove the heat source as soon as the embossing powder goes shiny.

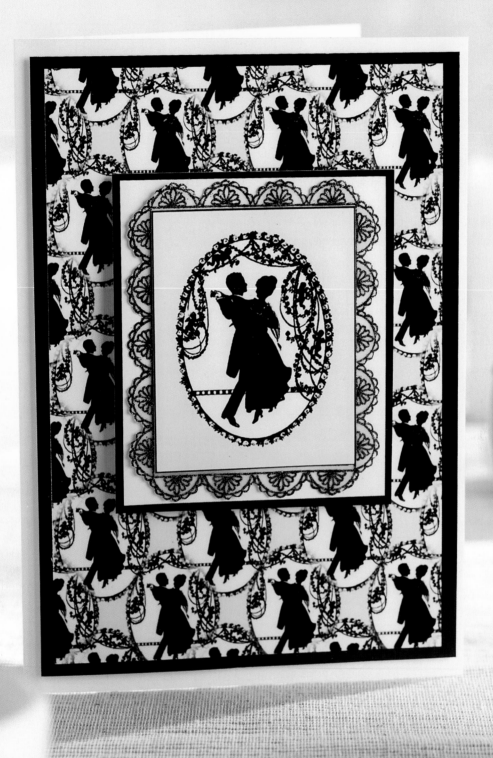

Dancing with Shadows

We often think of lace as being white, but here black lace looks very dramatic and glamorous as an embellishment behind the picture. If you don't have this exact stamp then there are a lot of similar lacy stamps available, or you can use a smaller stamp and create a design the same size as this one by stamping several images in a rectangle.

YOU WILL NEED

One sheet of A4 black mirror card

One sheet of patterned backing paper and one sheet of mixed toppers from the *Dancing with Shadows* CD

One sheet of 140gsm parchment

One sheet of A4 cream card, and a small extra piece

Scallop Lace rubber stamp and acrylic block

Black sparkly embossing powder

Double-sided tape

Silicone glue

Cocktail stick

2mm foam tape

Bone folder

Tweezers

Decoupage snips

Guillotine

Heat gun

Embossing inkpad

One sheet of A4 cream paper and decorative corner punch for insert (optional)

1 Fold the A4 sheet of cream card in half to create an A5 card blank. Strengthen the crease by firmly running the bone folder along it.

2 Cut a piece of black mirror card using the guillotine so that it is 0.5cm (¼in) smaller all round than the front of the folded cream card, that is, 1cm (½in) narrower and 1cm (½in) shorter. Cut a piece of the patterned backing paper so that it is 0.5cm (¼in) smaller all round than the mirror card. Put these to one side.

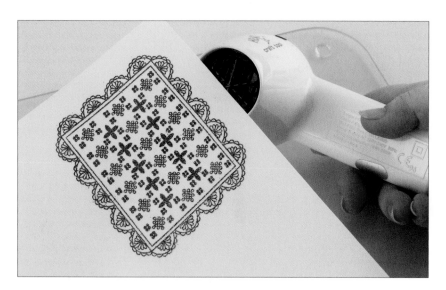

3 Attach the rubber stamp to the acrylic block (see page 10), ink the stamp using the embossing inkpad and stamp the image on to the parchment. Sprinkle on the black sparkly embossing powder and heat with the heat gun (see page 11).

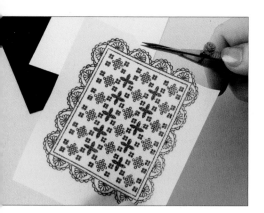

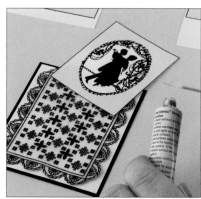

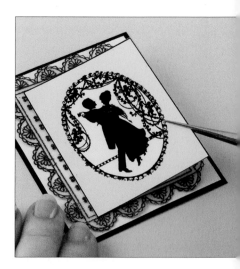

4 Cut carefully around the outside of the stamped image using the decoupage snips. Cut a small piece of cream card the same size as the lace design and a piece of black mirror card slightly larger. Layer the cream card and the mirror card using double-sided tape. Apply a few smears of silicone glue to the back of the stamped image and attach it to the cream card.

5 Cut out the medium-sized topper from the sheet and attach it to the lace design using silicone glue. Just a few smears of glue applied to the stamped image using a cocktail stick will be sufficient.

6 Position the topper centrally on the lace design using tweezers.

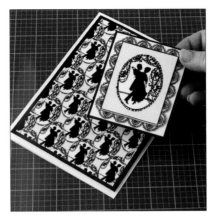

7 Attach pieces of 2mm foam tape to the back of the large piece of black mirror card you cut out earlier.

8 Attach the black mirror card to the front of the card blank, then the patterned backing paper, and finally the topper. Use 2mm foam tape each time for a raised effect.

9 As a final touch, add a folded piece of cream paper, slightly smaller than the card, as an insert. Attach it using a small strip of double-sided tape placed along the fold on the top surface, and round the corners using a decorative corner punch.

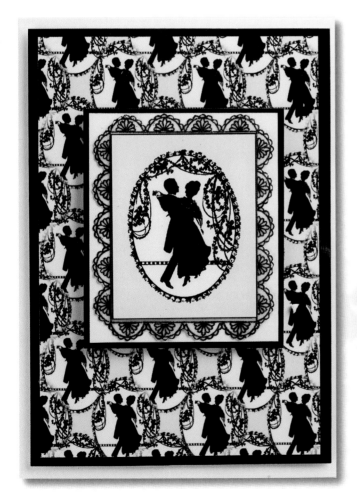

Lilac Circle
(below)

Here a combination of pre-printed lace papers and embossed parchment makes a gorgeous frame for a little spray of pressed love-in-a-mist and rose leaves.

Lily Bouquet
(right)

The paper calla lilies and ivy are tied simply with a ribbon, but what makes this card really special is the lacy embossed parchment behind them. The William Morris-inspired papers that back this design complete the faded romantic look of this card.

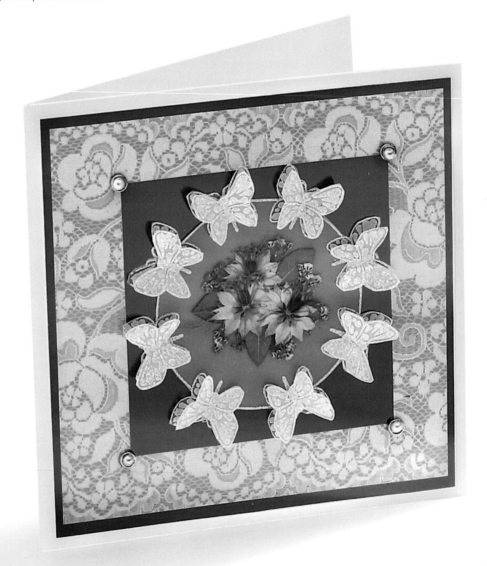

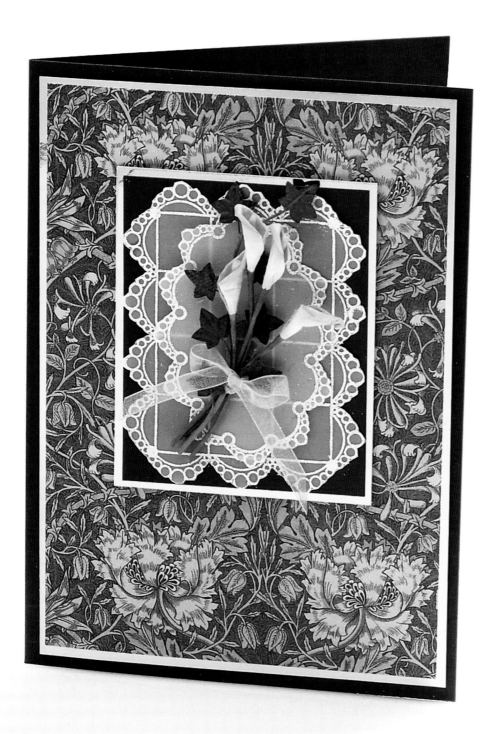

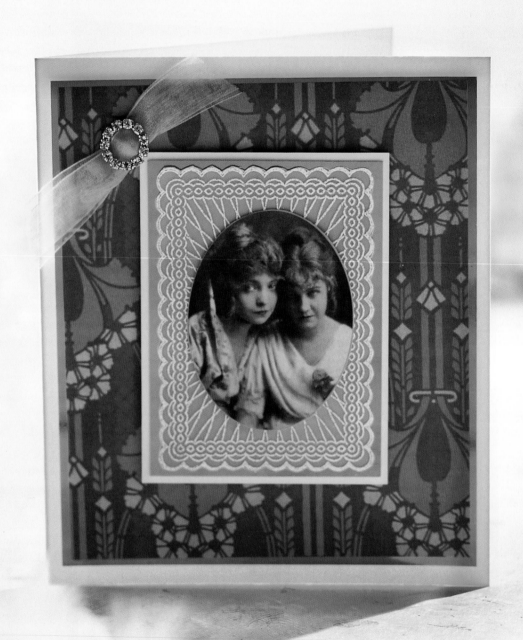

Sisters

I fell in love with this picture when I first saw it – there are many occasions when we would like to send a special card to a sister we love or a close friend, and this image gave me all the inspiration I needed to design one.

The background paper is art deco in style, which I feel goes well with the age of the photograph, and yet again the stamped and embossed lace makes the card into something really special.

You will need

One sheet of A4 copper mirror card

One sheet of A5 backing paper from the *Art Nouveau Patterns* paper pad

One sheet of 140gsm parchment

One sheet of A4 cream card, and a small extra piece

One vintage sepia photograph

Rectangular Doily rubber stamp and acrylic block

White sparkly embossing powder

Pink organza ribbon, approx. 15mm (¾in) wide

Small rhinestone buckle

Double-sided tape

Silicone glue

2mm foam tape

Bone folder

Tweezers

Decoupage snips

Guillotine

Heat gun

Embossing inkpad

One sheet of A4 cream paper and decorative corner punch for insert (optional)

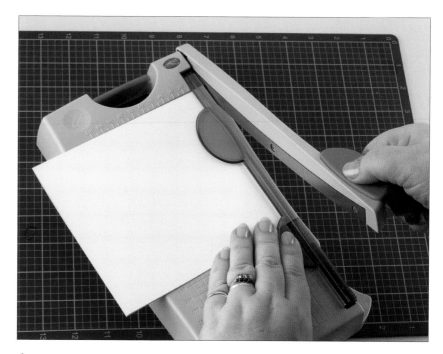

1 Fold the A4 sheet of cream card in half to create an A5 card blank. Strengthen the crease by firmly running the bone folder along it. Trim the card a little smaller to balance the photograph and stamped doily design, to 14.5 x 17cm (5¾ x 6¾in).

2 Cut a piece of copper mirror card using the guillotine so that it is 0.5cm (¼in) smaller all round than the front of the folded cream card, that is, 1cm (½in) narrower and 1cm (½in) shorter. Cut a piece of the patterned backing paper slightly smaller than the mirror card, and attach the two together using double-sided tape. Put to one side.

3 Attach the rubber stamp to the acrylic block (see page 10), ink the stamp using the embossing inkpad and stamp the image on to the parchment. Sprinkle on the white sparkly embossing powder and heat with the heat gun (see page 11).

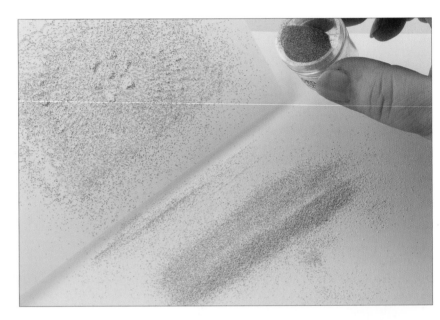

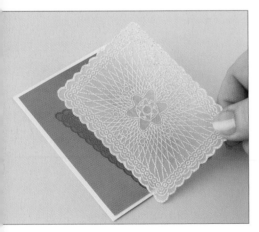

4 Trim carefully around the outside of the stamped design. Cut a small piece of cream card 0.5cm (¼in) larger all round than the stamped image, then a piece of copper mirror card just slightly smaller than this. Layer these using small strips of double-sided tape.

5 Trim around the outside of the photograph (the final image needs to fit neatly inside the stamped design). Attach the photograph to the parchment using a few smears of silicone glue.

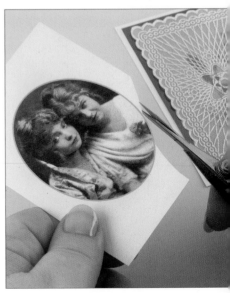

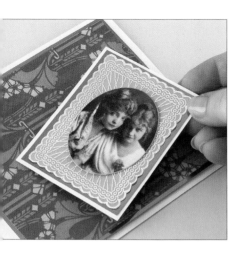

6 Assemble the card, using 2mm foam tape to attach the mirror card and patterned backing paper to the card blank, and finishing with the topper.

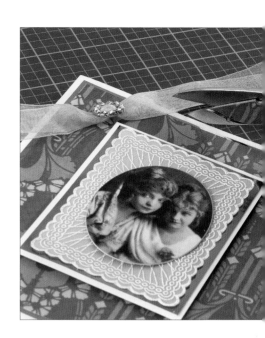

7 Thread the pink organza ribbon through the rhinestone buckle and attach it to the top left-hand corner of the card with silicone glue. Trim the ribbon to the edge of the card. Add an insert if desired (see page 15).

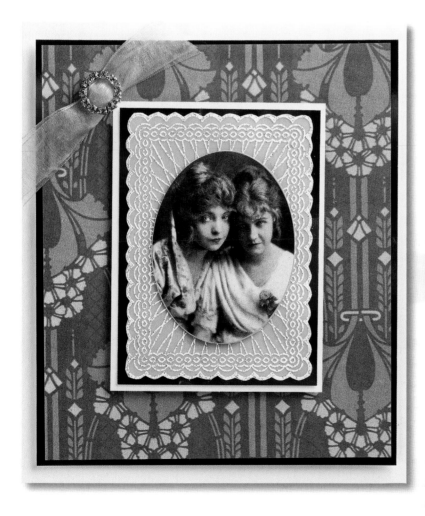

ABC Baby

This little baby's outfit has been stamped and embossed in pink on some pearl card and then backed with more parchment lace. It is a fun and simple card for a new arrival!

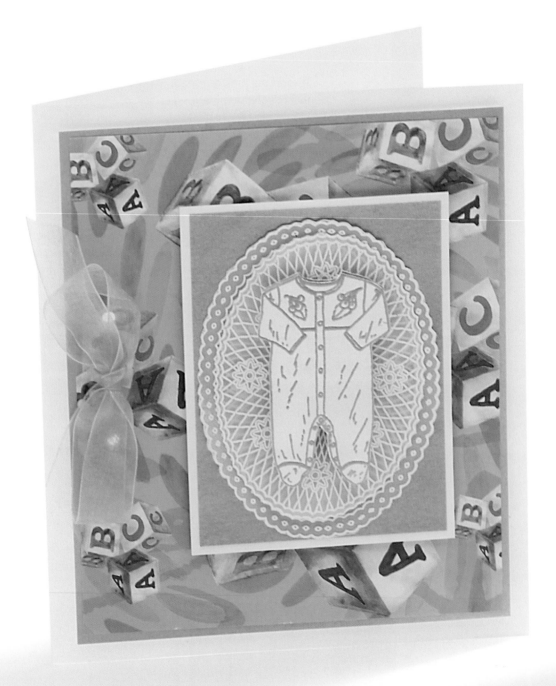

Victorian Rose

This is such a pretty card! The lace has been stamped in both gold and white, which adds a lovely detail, and the rose and backing paper are both from the Victorian Flowers *CD, though similar floral designs will work just as well.*

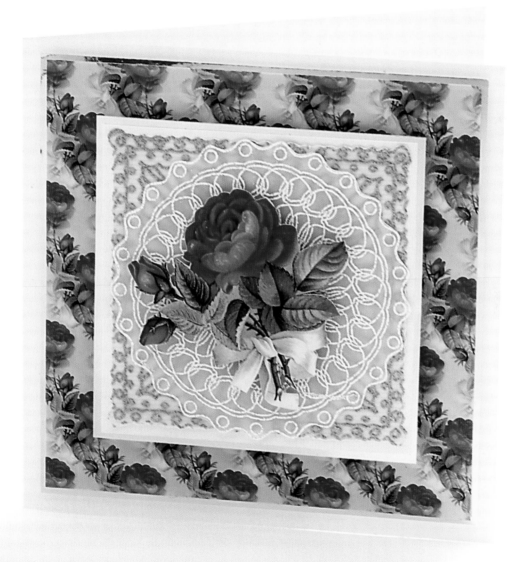

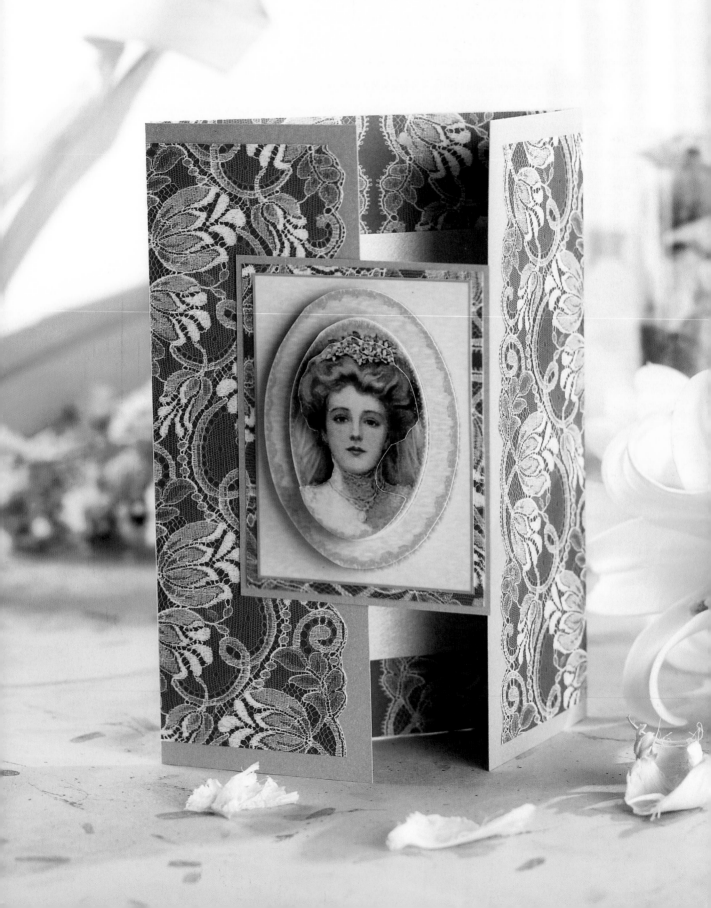

Victorian Bride

As with all the cards in this book, you can use the ideas and techniques described here with any materials you might have in your craft stash. Any pretty Victorian lady would look lovely decoupaged on to the centre of this card, and you could use different backing papers too. The gate-fold design of this card is unusual and opens up many possibilities for cardmaking.

YOU WILL NEED

Three sheets of A5 backing paper from the *Country Lace* paper pad

One sheet of four same-size toppers from the *Victorian Romance* CD

One sheet of A4 silver card, and a small extra piece

Double-sided tape

Silicone glue

Bone folder

Tweezers

Decoupage snips

Guillotine

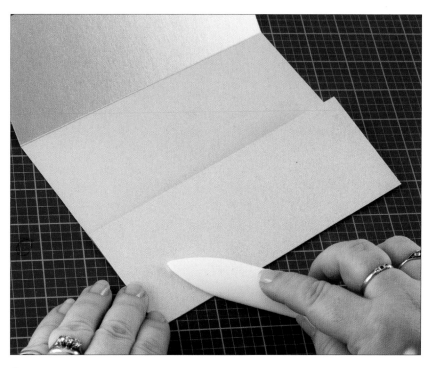

1 Fold the A4 sheet of silver card to create an A5 gate-fold card blank. Do this by dividing the card into quarter sections along its longest edge and folding in the first and last sections. Strengthen the creases by firmly running the bone folder along them.

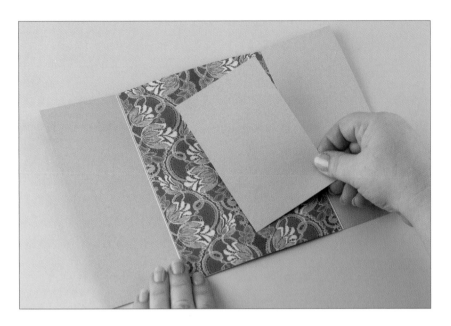

2 Cut a piece of A5 lace backing paper so that it fits in the centre of the card and attach it using double-sided tape. Attach a small piece of silver card in the centre on which to write your message.

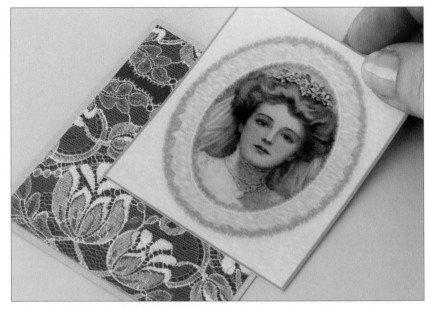

3 Take another sheet of the lace backing paper and cut it in half down its length. Trim each half carefully around the lace pattern along one edge. Measure them against the two panels on the front of the card, and cut them down to allow a little silver card to show along the top, bottom and inside edge.

4 Cut out one of the Victorian bride images. Create the central topper by cutting a piece of silver card approximately 1cm (½in) larger all round than the image, and a piece of lace backing paper 0.5cm (¼in) smaller all round than the silver card. Layer the silver card, backing paper and Victorian bride using double-sided tape.

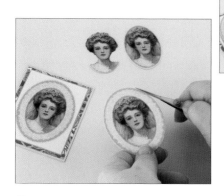 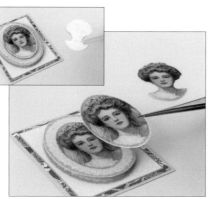 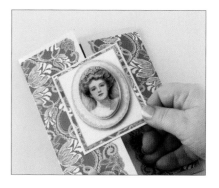

5 Using the remaining three images, cut one around the outer oval frame, one around the inner oval frame, and one around the outline of the bride herself.

6 Layer the images using spots of silicone glue to create a three-dimensional decoupage effect. Leave the glue to dry overnight, or at least for several hours.

7 Attach the left-hand side of the completed topper to the left-hand side of the card using double-sided tape.

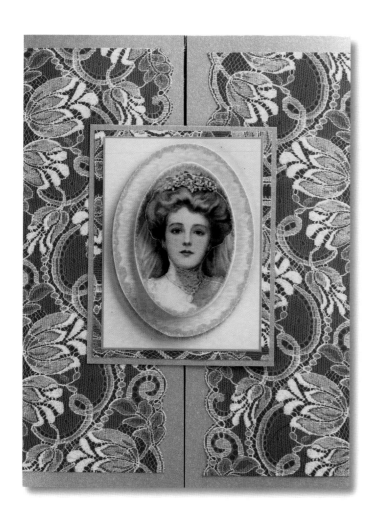

Hot Pink

This card uses a really strong pink, which makes a very bold statement. The flower is decoupaged with several layers and this could be reproduced in many different colour schemes to match whatever flower you choose to use.

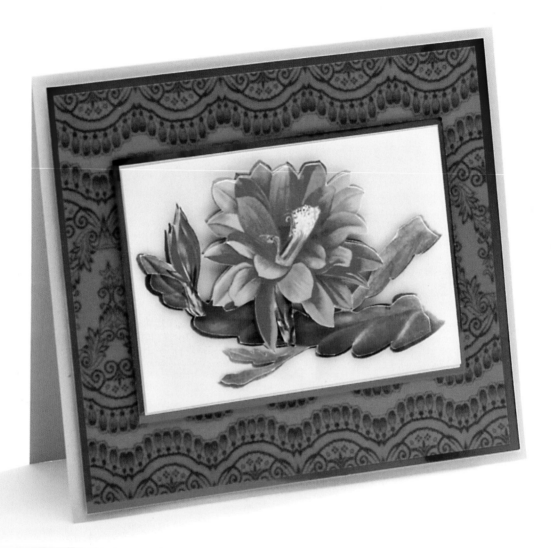

Black and White Christmas

This unusual Christmas design features a die-cut image from an embossing and die-cutting machine, such as a Wizard. The dainty detailing and black lace background make a very different style of Christmas greeting.

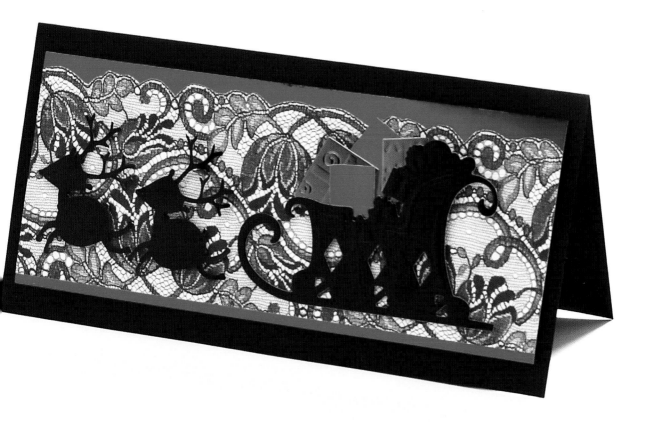

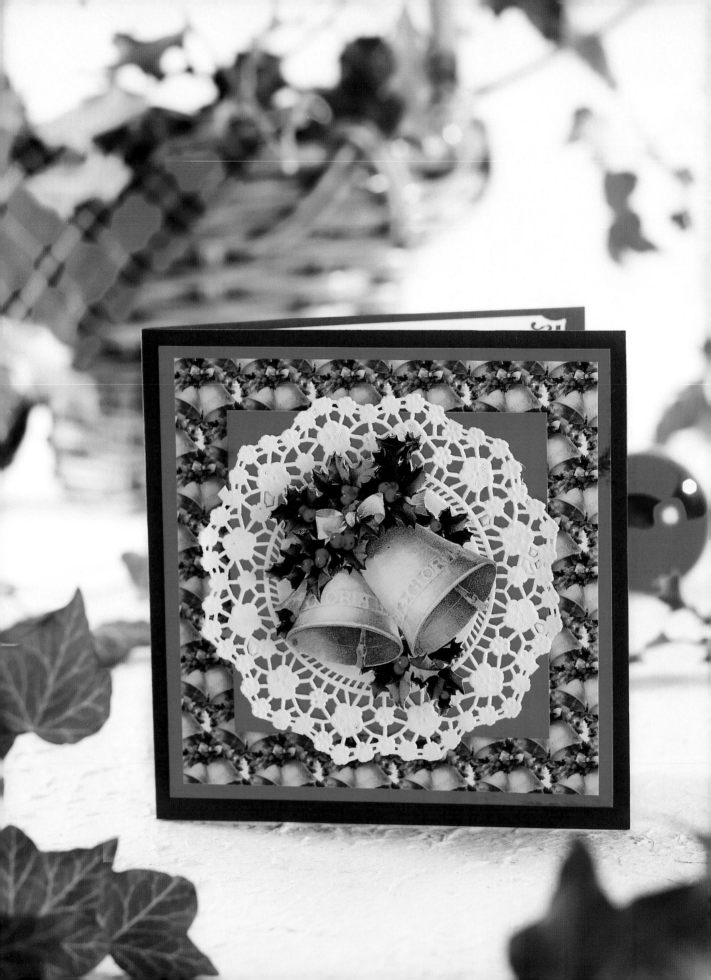

Christmas Bells

Christmas is possibly the time when cardmaking is most popular, and how nice it is to have an idea that looks great but isn't too time-consuming to make. This project requires the small-size paper doilies that are intended to go under festive drinks or cups.

You will need

One sheet of A4 red mirror card

One sheet of mixed-size bells and one sheet of matching patterned backing paper from the *Enchanted Christmas* CD

One sheet of A4 forest green card

One small paper doily

Double-sided tape

2mm foam tape

Silicone glue

Bone folder

Tweezers

Decoupage snips

Guillotine

One sheet of A4 cream paper and decorative corner punch for insert (optional)

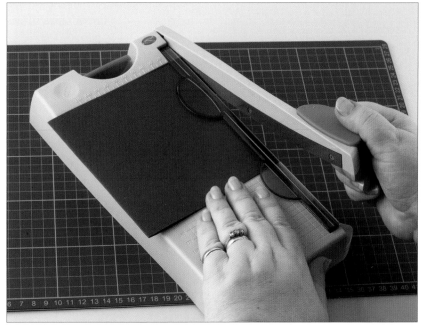

1 Fold the A4 sheet of green card to create an A5 card blank. Strengthen the crease by firmly running the bone folder along it. Trim the card blank so that it is 14.5cm (5¾in) square.

2 Cut the red mirror card so that it is approximately 0.5cm (¼in) smaller all round than the front of the green card blank. Cut the patterned backing paper slightly smaller than this. Attach the mirror card and the patterned paper to the card blank using double-sided tape.

3 Choose one of the bell toppers and cut it out carefully using the decoupage snips.

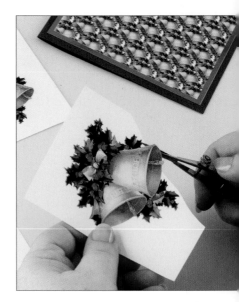

4 Measure the diameter of the paper doily and cut a square of red mirror card slightly smaller than this. Attach strips of 2mm foam tape to the back of the mirror card square and attach it to the front of the greetings card.

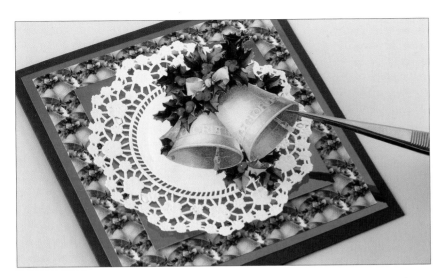

6 Make an insert for the card if you wish (see page 15).

5 Attach the paper doily and the bells to the mirror card using spots of silicone glue for a raised effect.

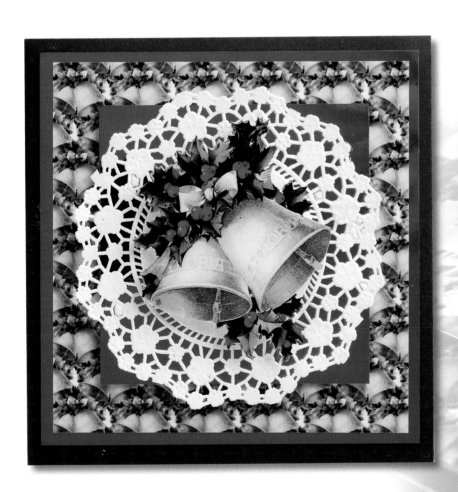

Oriental Lace
(below)

On this card the doilies have been folded in half to make fan shapes and slotted in between fans cut from a decorative paper printed from a CD. This design would work well with real miniature fans.

Sepia Bride
(right)

This card uses a large rectangular doily that has been wrapped round the card. It is held on to the card with a ribbon bow rather than glue, which might seep through the paper.

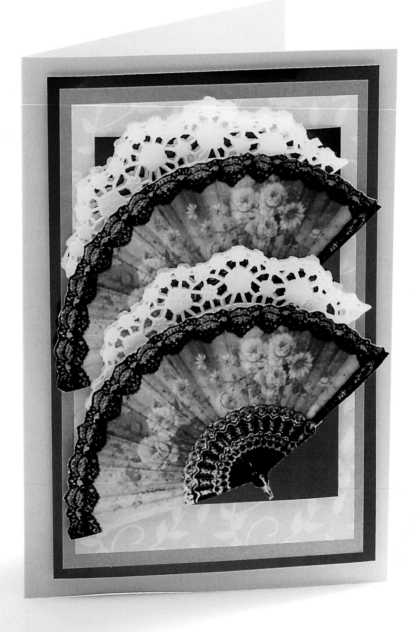

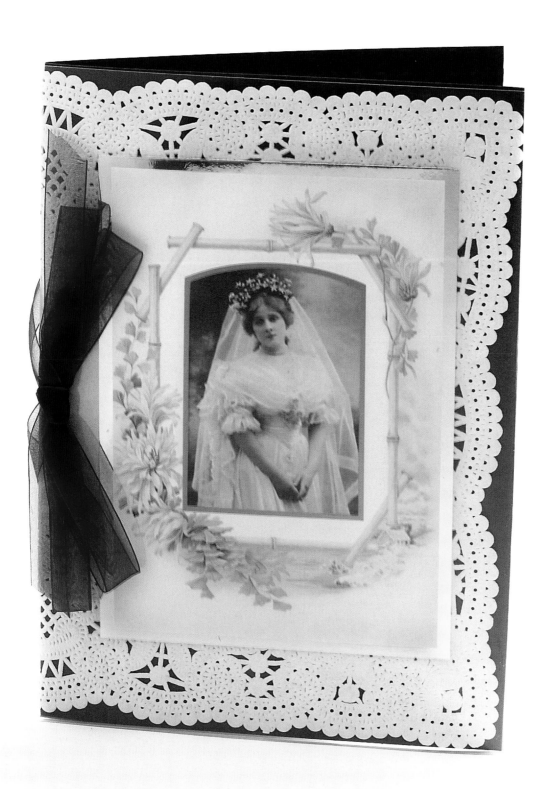

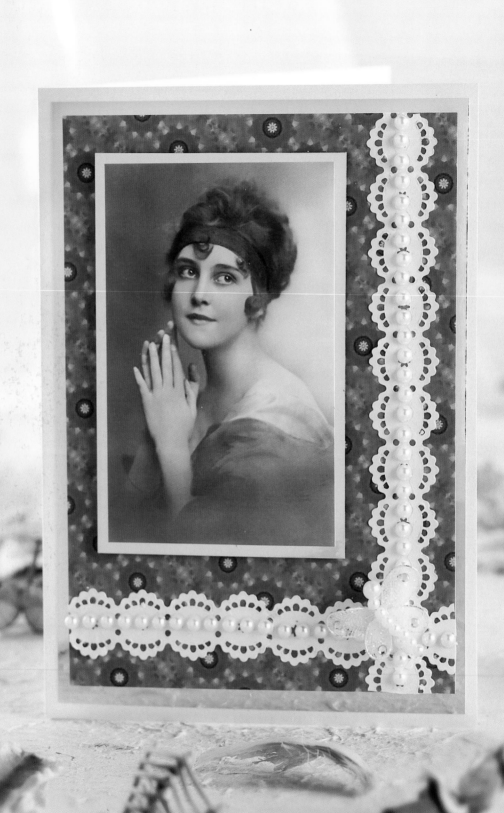

1920s Glamour

I just love this era – the fashions then were so glamorous and stylish. You could recreate this card with a picture of a relative if you are lucky enough to have old photographs, or use any glamorous picture you have to hand. The self-adhesive ribbon lace and pearls are very useful for a quick embellishment that lifts the card completely.

You will need

One sheet of A4 gold mirror card

One sheet of patterned backing paper and one sheet of matching images from the *Fashion Boutique* CD

One sheet of A4 ivory card

Two strips of adhesive paper ribbon

Self-adhesive pearl strip

Pearl butterfly embellishment

Double-sided tape

Silicone glue

2mm foam tape

Bone folder

Tweezers

Guillotine

One sheet of A4 cream paper and decorative corner punch for insert (optional)

1 Fold the A4 sheet of ivory card to create an A5 card blank. Strengthen the crease by firmly running the bone folder along it. Cut the piece of mirror card so that it is approximately 0.5cm (¼in) smaller all round than the card blank, and cut the patterned backing paper slightly smaller than this. Attach the mirror card to the card blank, and the patterned paper to the mirror card using double-sided tape.

2 Cut out one of the medium-sized images. Cut a small piece of gold mirror card approximately 0.5cm (¼in) larger all round, and attach the image to it using double-sided tape.

3 Attach the topper to the front of the card using 2mm foam tape. Offset it slightly, so that it is positioned in the top left-hand part of the card.

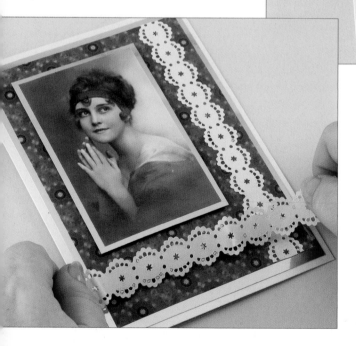

4 Cut two strips of adhesive paper ribbon. Peel the backing off one and attach it down the right-hand side of the card. Attach the other piece along the base.

5 Add a strip of self-adhesive pearls along the centre of the paper ribbon in each direction, then use silicone glue to attach the pearl butterfly at the point where they cross. Add an insert if desired (see page 15).

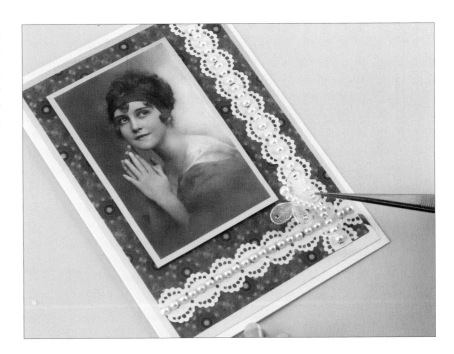

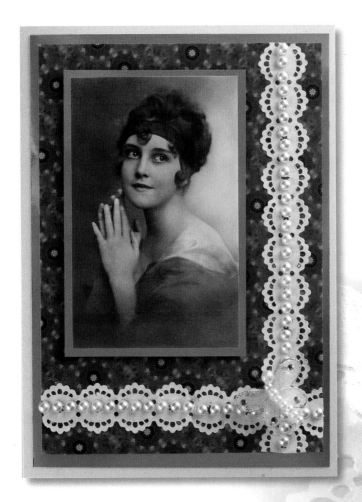

Blue Straw Hat

A pretty, summery card that uses an image of a straw hat and more of the paper lace ribbon with flowers. The ribbon is made into a faux bow to avoid having to tie it. Perfect for a summer birthday or party invitation.

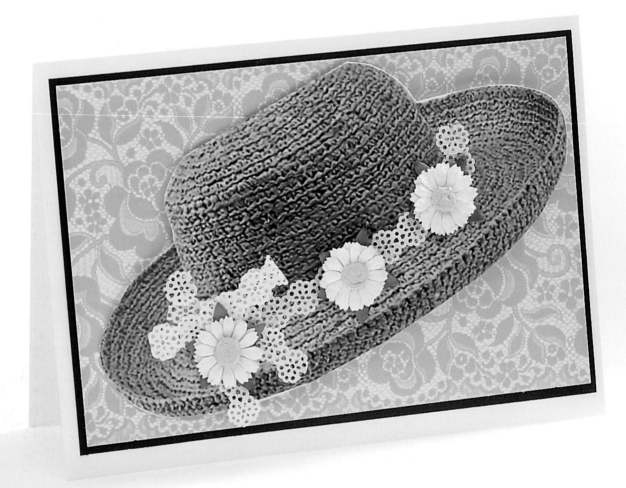

Easter Chicks

This sweet little Easter painting is from the Cardmaker's Year *CD, though any similar image will work just as well. It has a nostalgic feel, reminiscent of old-fashioned childhoods. The daffodils and lace around the edge complete the look nicely.*

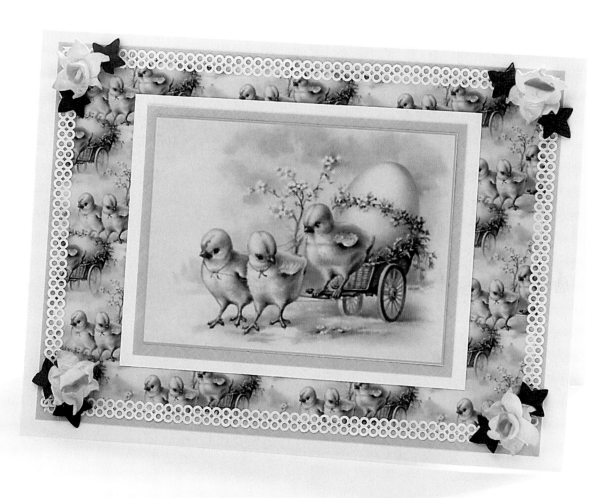

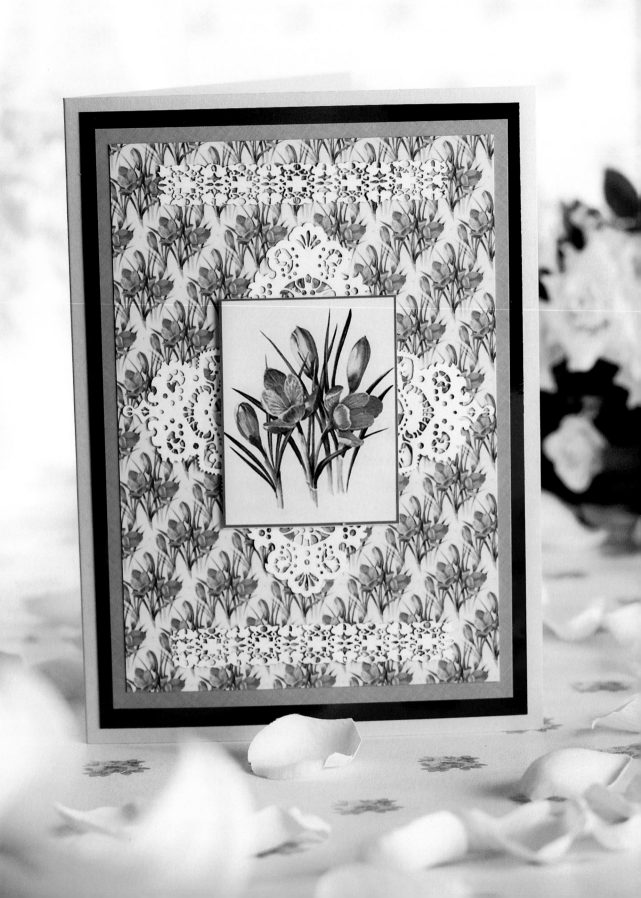

Easter Crocuses

This card uses commercially available laser-cut lace, but you could also use real fabric lace to create a similar effect. The soft lavender colour scheme blends beautifully with the colour of the crocuses to make a Spring greeting that would be happily received by anyone at Easter.

YOU WILL NEED

One sheet of A4 purple mirror card

One sheet of A4 pearlescent lilac card

One sheet of mixed-size crocus images, one sheet of matching patterned backing paper and one sheet of matching plain lilac backing paper from the *Cardmaker's Year* CD

A square and two strips of laser-cut lace

Double-sided tape

Silicone glue

Bone folder

Tweezers

Decoupage snips

Scissors

Guillotine

One sheet of A4 cream paper and decorative corner punch for insert (optional)

1 Fold the A4 sheet of lilac pearlescent card to create an A5 card blank. Strengthen the crease by firmly running the bone folder along it. Cut a piece of purple mirror card so it is 0.5cm (¼in) smaller all round than the card blank. Attach the mirror card to the front of the card blank using double-sided tape.

2 Cut the piece of lilac backing paper approximately 0.5cm (¼in) smaller all round than the mirror card and attach it to the mirror card using double-sided tape. Cut the crocus-patterned backing paper 0.5cm (¼in) smaller again, and attach this to the top.

3 Cut out one of the smaller crocus images, retaining the dark green border.

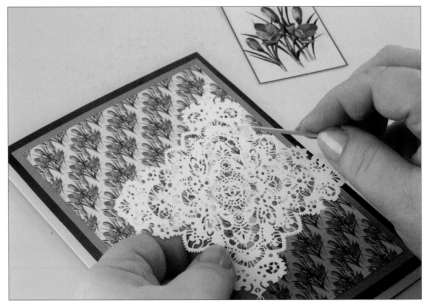

4 Trim the square of laser-cut lace so that it fits within the crocus-patterned paper. Apply silicone glue to the back using a cocktail stick and attach it in a diamond shape in the centre of the card. Attach a strip of laser-cut lace above and below it.

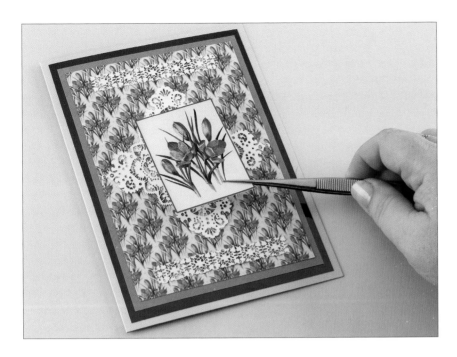

5 Apply spots of silicone glue to the back of the crocus image and place it in the centre of the card. Add an insert if you wish (see page 15).

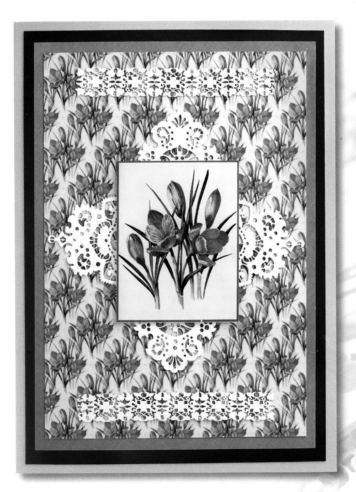

Lilac Blossom Time

This is one of my favourite images from my Fashion Boutique *CD, and there are numerous designs you can create with it. Here I have paired it with laser-cut lace embellishments and a collection of soft lilac cardstock.*

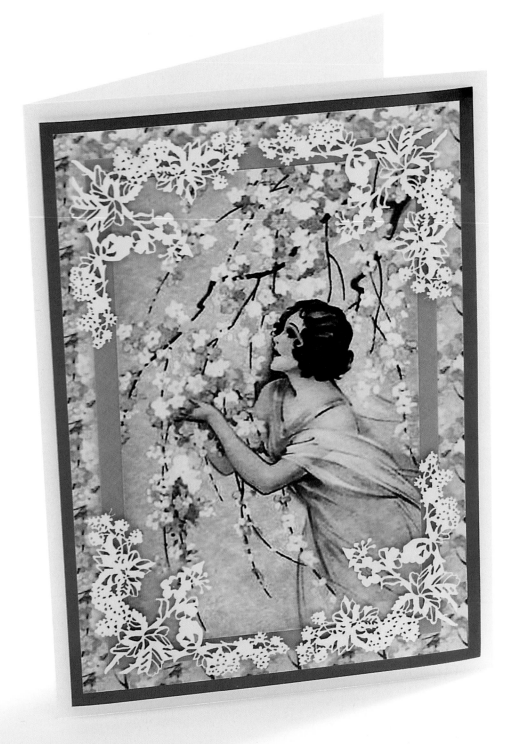

Vintage Shoes

Long, slim cards are very popular. This is a great format in which to display images of pairs of shoes, but you could also use hats or bags for a similar effect. Use traditionally male images placed in a column down the card for a husband, brother or boyfriend.

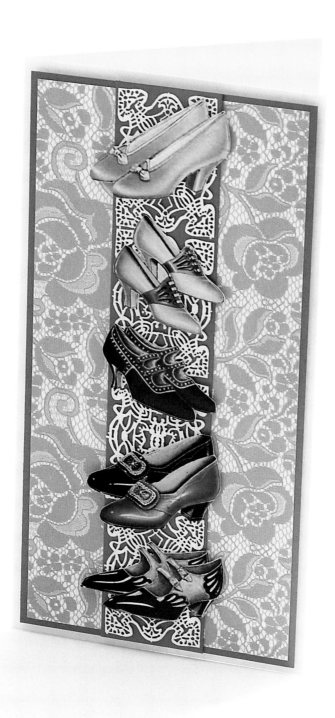

Index

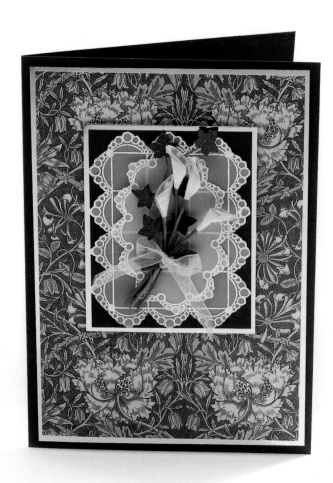